HOW TO DRAW AND PAINT
THE FIGURE

Macdonald

CONTENTS

HOW TO USE THIS BOOK

Here are step-by-step demonstrations of a range of subjects in different media, designed to illustrate different ways of painting and drawing. To get the most out of these exercises, study each one first and then either re-paint or re-draw it yourself, or apply the techniques to a subject or scene of your choice.

Copying. Don't be concerned about copying the exercises — many famous artists have borrowed ideas and painting techniques and have used them to develop their own individual style. Copying the exercises will make learning the techniques easier as you won't have to worry about finding a subject, composition or design.

Stay loose. Attack each painting or drawing vigorously and don't worry about making mistakes - the more you practise and experiment, the sooner you will see a dramatic improvement in your painting.

Experiment. Attack the subject boldly, taking risks with lines, colour, shapes and values will prevent your work looking tight and overworked. Apply paint freely and don't hold your brush too near the point or your brushwork will look tentative. You only need to hold the brush near the bristles when you are working on details. This also applies to drawing tools such as pencils or pastels. Start loosely, saving the detailed work for the finishing touches.

Keep it simple. Select simple subjects and compositions to start with. Restrict the number of colours you use and avoid overworking them. If you follow these simple rules you will soon produce surprisingly good paintings and then you can really start to experiment with more ambitious compositions and colour schemes and develop your own unique painting style.
 Happy painting!

A MACDONALD BOOK

© Quintet Publishing Ltd 1986

First published in Great Britain in 1986
by Macdonald & Co (Publishers) Ltd
London & Sydney

A member of BPCC plc

How to paint the figure —
The Macdonald Academy of Art
1. Figure painting — Technique I.
Series 751.4 ND1290
ISBN 0-356-12345-6

This book was designed and produced by
Quintet Publishing Limited
6 Blundell Street, London N7

Typeset in Great Britain by
Facsimile Graphics Limited, Essex
Colour origination in Hong Kong by
Hong Kong Graphic Arts Limited, Hong Kong
Printed in Hong Kong by Leefung-Asco
Printers Limited

Macdonald & Co (Publishers) Ltd
Greater London House
Hampstead Road
London NW1 7QX

Painting and drawing from life is one of the best established traditions of fine art and remains so for very good reasons. The figure provides the artist with a great variety of shapes and angles through which the artist can learn to understand the three-dimensional form. Part of the value of a life model is that the pose changes minutely all the time, and the play of light over form can be studied at length. Some artists, with a good knowledge of form and volume, prefer to use photographs as reference, but the flat image is lifeless and gives only part of the information to be gained from the real subject.

Knowing the right way to work, is an important part of the artist's skill. In the painting **below** the artist has been able to 'feel' the shapes, the substance, and the bulk of the body. He was aware of the way it occupies space, and displaces a certain amount of air. If, however, he were concentrating on the pattern-working possibilities of a subject he would see the outlines, the shapes, the silhouettes the forms cut out of the background. Thus the way you feel, your concerns at the moment, and the ideas that excite you will dictate the kind of image you produce. The same image drawn or painted on different days will vary, sometimes considerably so, this is why many great artists have returned to the figure throughout their lives, for them the subject is never exhausted and the more you know of it the further you can take the process of exploration. When you start to work from life try to put from your mind any preconceived ideas of how a figure study should look.

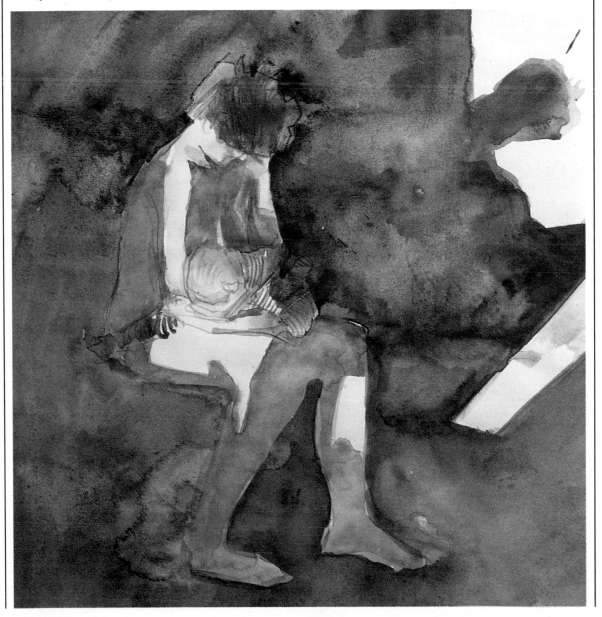

POSING THE MODEL

It is stating the obvious to say that the human body is a three-dimensional object, but the beginner is often tempted to consider only the full frontal view. There are many viewpoints which can be drawn, and all are interesting and worth studying. Your first decision is what pose you wish to draw and from which angle. Having posed the model move around him or her looking at the play of light on the form. Once you have selected a pose and a viewpoint you can start your drawing. The body is a volume occupying a certain space. It is helpful to think of it as a series of cylinders, each of which has a central axis and is linked with the spine. If you think of the body in this way you will realise that shift in one part of the body will have a ripple effect and will affect other parts of the body.

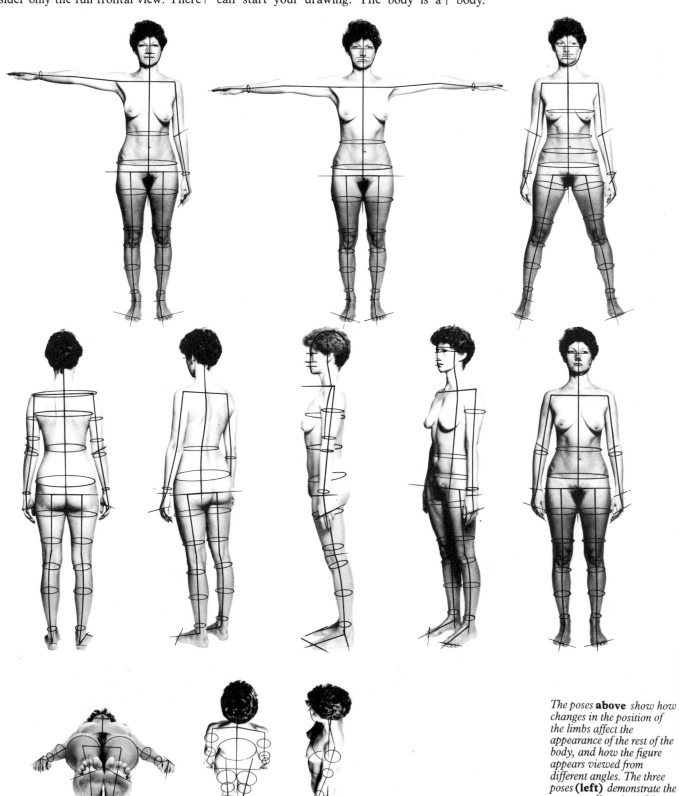

The poses **above** show how changes in the position of the limbs affect the appearance of the rest of the body, and how the figure appears viewed from different angles. The three poses **(left)** demonstrate the apparent distortion of the body through foreshortening when seen from steep angles.

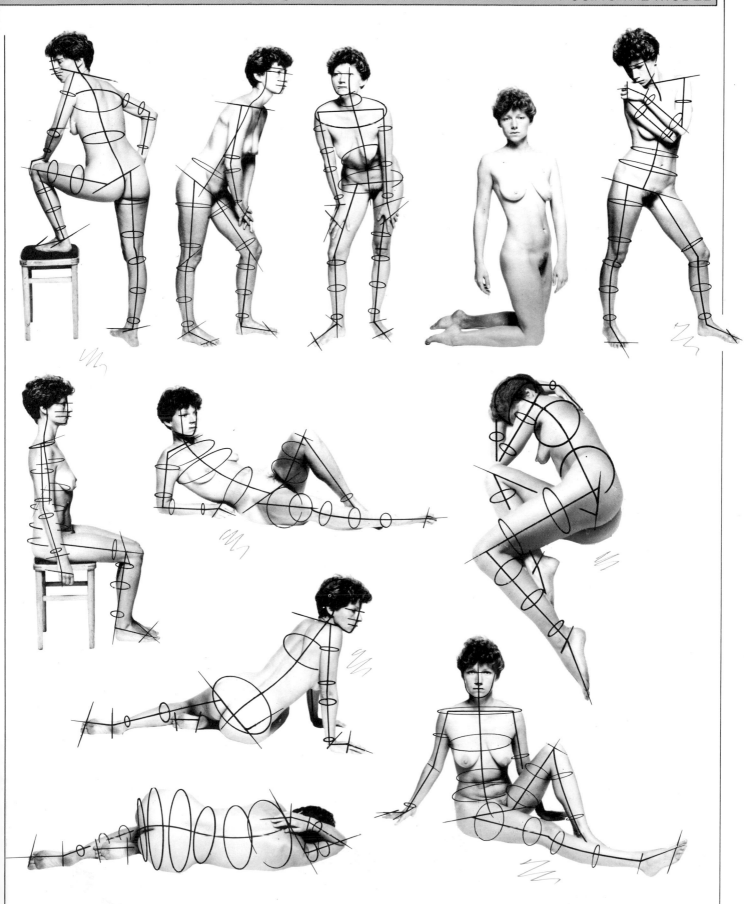

Because of its rhythmically co-ordinated structure, the body can fall into an infinite variety of poses **(above)**. *The slightest shift* in position radically alters the whole effect. The five poses in the **top row** show differences in the distribution of weight. With these types of pose it is important to establish the axes of the figure and their spatial directions. The axes worked out, the figure's directional lines should be ascertained by studying the direction in which different parts of the figure move and how they shift in relation to each other. Axes and directional lines help to establish the three-dimensional aspects of a form in space.

SKETCHING FROM LIFE

The artist's sketchbook is a very valuable possession. It is a record of his daily life, a sort of visual diary, and its contents are an endless source of inspiration, reference and amusement. The sketchbook can be used to explore a new idea, to resolve a particular problem or to jot down ideas for new compositions. And for the artist interested in the human figure, a sketchbook is essential — buses, shops, parks, restaurants and bars, anywhere where people gather, provide the artist with more material than he could ever hope to gather from a lifetime in the studio. The human form is infinitely varied and it is this variety rather than the ideal which tends to fascinate artists today.

There are a great many drawing media suitable for sketching — the one you select will depend on the way you work, your aspirations and the sort of images you want to create. The quality of the line is an important element of the finished work. Lines can be thick or thin, straight or wavy — the variations are endless. In freehand drawing the line has its own statement to make. A line which varies in weight can be used to convey the illusion of space or volume, thickening of the line can convey shadow or nearness to the beholder, a faint line can convey light or distance.

Different tools allow you various degrees of flexibility in the kind of mark you make and each has its own range of marks and characteristic features. Experiment with all of them and when you find the one which suits you make sure that you are never without a sketchbook and a drawing tool.

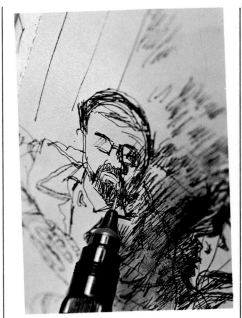

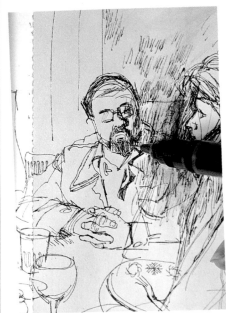

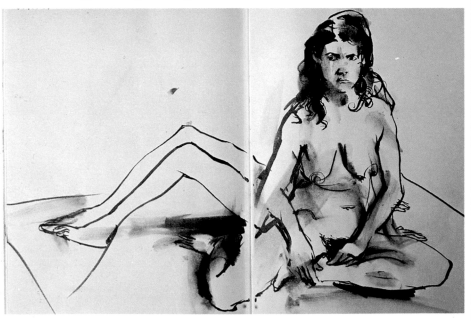

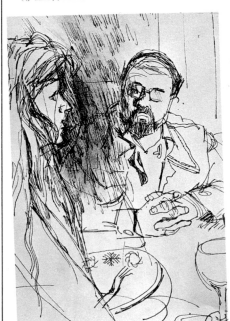

The two figures (above) were drawn with a Chinese brush and ink. The sharp, yet freely drawn line lends itself perfectly to the undulating contours of the human form. The line has no fixed width, instead it swells and thins along the concave and convex areas it represents. A rapidograph was used for the drawing on the far right. The fine, consistent line creates detailed features such as the beard (top) and areas of deeper tone (centre). The effects of rapidograph vary from the scratchy 'etched' line quality, to strong, dramatic areas of contrasting tone (bottom).

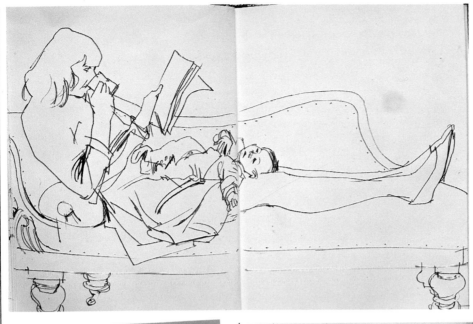

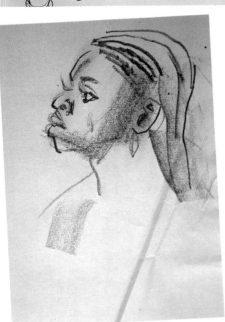

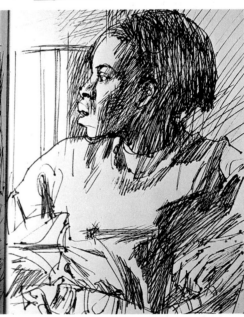

*A cheap ball-point pen was used for this charming sketch of a mother and child (**top left**). Biro is convenient, clean and has a lively spontaneity when used freely.*

*The broad uneven lines in the portrait sketch (**above**) were made with the side of soft pencil lead.*

*The bold, even line of a broad rapidograph was used to create an effective silhouette in front of the stark, white window (**centre right**). A detail of the drawing (**right**) shows how the dense layers of short jerky lines have been used to depict different tones of shadow.*

IMPLYING MOVEMENT

Here we show some paintings which imply a sense of direction and movement. They do so, to a large extent, by clever composition, by the way the figure fits within the frame and the way it is positioned within that space. The way a subject is placed on a canvas can radically affect its importance in the painting. The centre foreground is usually the dominant place, so moving the subject further up the picture plane may create an impression that it is further away, even if the image is painted the same size on the canvas.

There are many ways of indicating movement within a painting. An artist manipulates the viewer, persuading him to follow a direction that the artist intends by tricking the eye into following a path around and even off the painting. Composition can only really exist when the area of the picture is clearly defined, for this forces the artist to make decisions about how to work within limited parameters. Our forefathers working on their cave walls were untrammelled by such decisions, their picture area was only limited by the size of the rock face and had no clearly defined limits. However, man has a great ability to

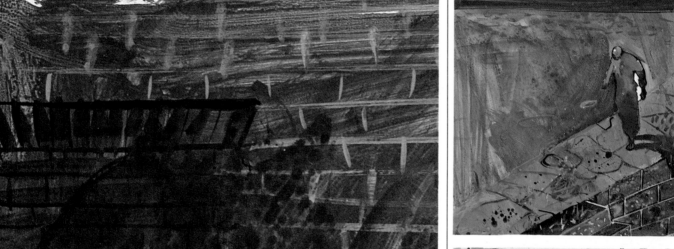

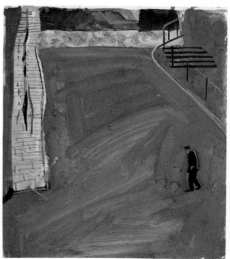

*In the three compositions (**above**), the figures are all placed in a way which attracts the eye to the centre of the picture. The opposite is true of the picture on the **left**. The figure is almost walking off the edge of the paper, and the viewer's eye immediately drops to **bottom left corner** where it follows the direction of the walking man — out of the picture.*

make a virtue out of a necessity and so it is with the limited area of the canvas. Suppose you decided to paint one single figure on a canvas and suppose further that the size of that canvas was specified — you would still be left with an incredible range of choices and could create many different pictures depending on how you positioned the image.

By introducing another image into the composition you can create new variables. The way the figures are placed relative to each other sets up tensions and movements. Move them in relationship to each other and these changes overlap them and you once again imply distance.

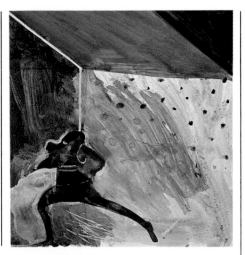

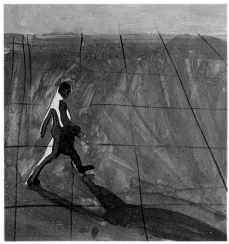

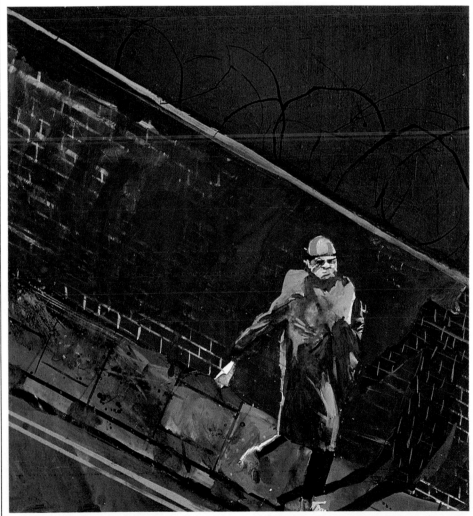

The moving figures **(above)** *are unusual in their positioning. The dancer* **(above left)** *is standing on the base of the picture; the other figure* **(right)** *is seen from above. He is walking across a canvas which is devoid of content apart from the shadow extending from the figure across the empty expanse of ground. The grey figure* **(left)** *moves between the diagonal lines of the composition — the wall, the pavement, and the yellow lines — giving a strong slanting emphasis to the picture. The lines all converge at the* **bottom right corner** *— the direction in which the figure is moving. The frieze* **(below)** *shows a whimsical composition of a figure striking different attitudes as he moves across the picture, from one end to the other.*

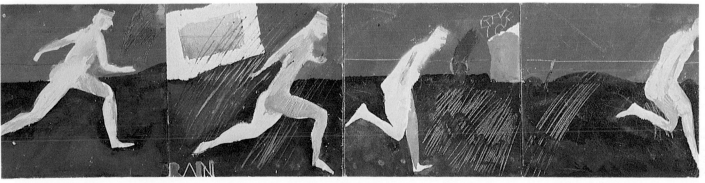

MAN AT WORK

When drawing from life there is no time to ponder such details as the form of an eye socket, the type of crease or the position of a feature in a tilted head. All this knowledge must become so much a part of your subconscious that it automatically comes to the surface when you need it. When making rapid sketches from life concentrate on the few lines that express the essentials. You must accept that much will have to be omitted, for time is short. The emphasis must be on action and form.

There are many hunting grounds for suitable subjects. If you are looking for activity a large railway station should provide you with ample material. On the other hand, people in a park on a sunny day will provide you with many examples of people at rest.

Note the artist's economy of line, the discreet use of simple shading and the importance of the pose. You have to like people to be able to sketch them successfully. In order to record the personality and individuality it is important to get the significant points down on paper rejecting all that is not essential. The outline of a figure is very important. It must be just right or the individuality in both pose and shape will be lost. Get the proportions and angles right — but the details of a peculiar profile or a strange nose are unimportant. A pencil is a simple and responsive sketching tool — when sketching convenience is the primary consideration.

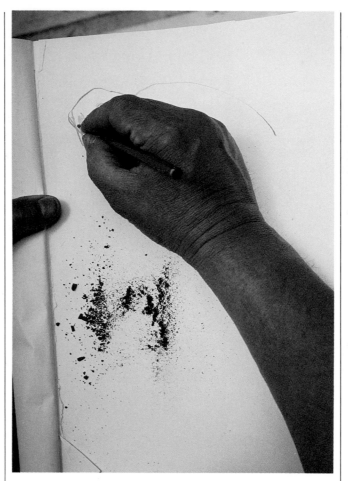

Work quickly to capture the position and movement of the subject **(bottom left)**. *Use pencil or charcoal, and have a small amount of charcoal or chalk dust close at hand, ready to lay in the shadows rapidly as you work* **(left)**. *Many people do not try to sketch because they think the results will be disappointing, but if you never start you will never improve and, after all, nobody has to see your work until you decide it is good enough.*

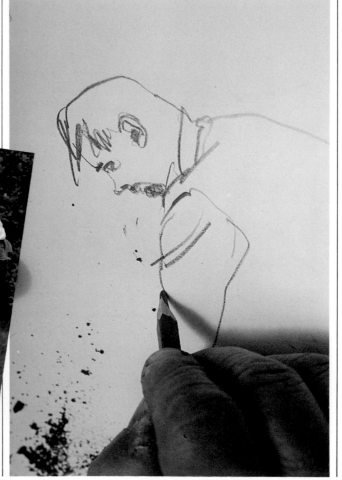

Sketch the figure quickly, paying more attention to the main lines and directions of movement than to detail **(left)**. *Do not aim to produce a highly finished drawing — if the figure changes position often, try making a series of very basic sketches depicting the changing attitudes.*

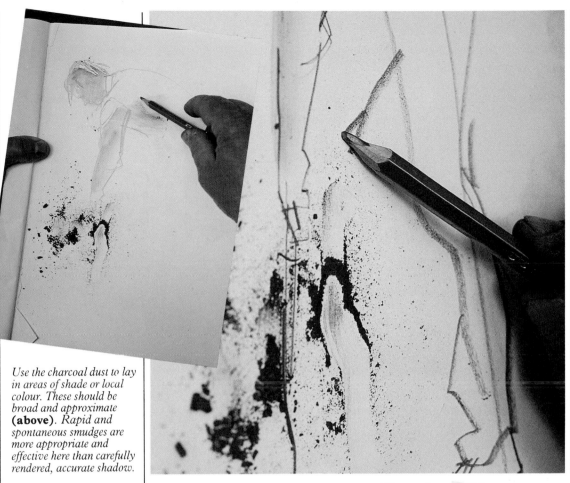

Movement can be emphasized by using heavy lines. Use the side of the pencil lead to depict weight or strength **(left)**. Develop the sketch by adding stronger tone **(bottom left)** and as much linear information about the figure as you have time to record **(bottom right)**.

Use the charcoal dust to lay in areas of shade or local colour. These should be broad and approximate **(above)**. Rapid and spontaneous smudges are more appropriate and effective here than carefully rendered, accurate shadow.

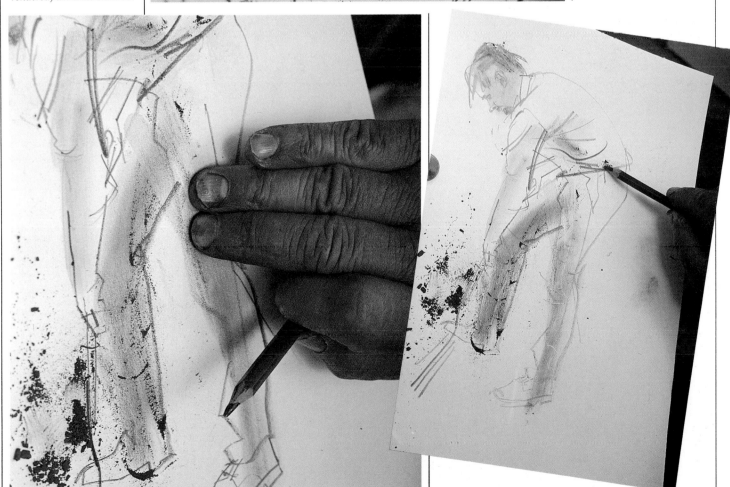

SEASCAPE WITH FIGURE

Here the artist has chosen to use watercolour. The subject is interesting consisting of a large area of sea and sky and, in the foreground among the breakers at the edge of the shore, a young girl. Water is a subject which many people baulk at tackling. It is such an insubstantial thing that the thought of capturing it in anything as concrete as pigment is daunting. The best approach is not to think about the subject but to paint what you see. Water is a colourless substance which is highly reflective and light-scattering when in a body and depends for its appearance on what surrounds it. Thus the sea changes colour depending on the light, the time of year and the weather conditions. It can be bright blue, slate grey, dark green or any shade between, so as you can see we can offer no formula for painting this everchanging subject — you must rely on observation.

If the paint is to keep the freshness so typical of good watercolour painting, it is essential that the first layer of paint is dry before you start working over it. This of course assumes that you require discrete overlapping layers of paint. There may be occasions when you want the colours to run into each other, in which case you will work

The artist now mixes a light flesh colour and using a medium sized sable brush starts to apply thin paint to the flesh areas of the figure. The paint is applied flatly — light and shadow will be worked in later (**above**).

Here the artist transfers his composition from his sketchbook onto a piece of good quality, stretched watercolour paper. His initial drawing is accurate because it is difficult to

correct watercolour once it has been applied (**above**). *The paper is stretched by first wetting it and then using gummed paper to fix it to a drawing board. Then it is left to dry.*

The artist now washes in the yellow of the hair, using thinly diluted paint and a loaded brush (**right**). *These initial washes are the basis for darker tones which will be added later.*

wet-into-wet. But for the beginner it is much easier to work wet-over-dry for it takes a great deal of confidence born of skill and experience to manipulate two areas of wet colour successfully.

The artist starts by establishing the main outlines of the composition in pencil and then develops the tonal modulations of the form. Using a fairly small brush he paints in discrete areas of tone, first ensuring that the preceding layers are dry. He perceives the darker skin tones as flat coloured forms, and lays in the colours so that there are sharp lines to provide the transition between one tonal area and another. He does not bleed one colour into the other, but these highly contrasted areas of light and shade convey very precisely the quality of bright sunlight on suntanned skin.

The artist works carefully, analyzing the subject and planning his method of working in advance. He is nevertheless willing to incorporate any fortuitous happenings — anyone who uses watercolour must be prepared to, for it is one of the most temperamental, but also the most exciting, of painting media.

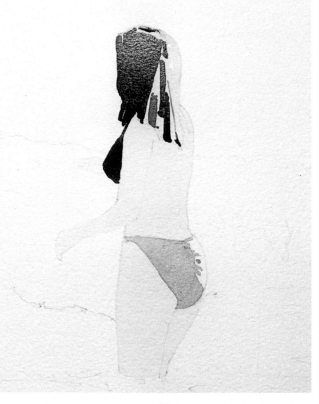

When the first tints are dry the artist starts to work over them. He uses a solution of burnt umber to lay in the dark tones of the hair and a more dilute solution of the colour is used to lay in the bottom half of the girl's bikini. Burnt sienna and black are used for the bikini top (**left**).

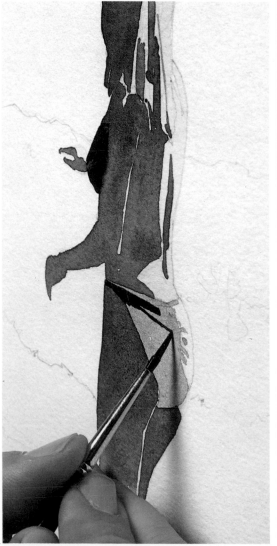

Using a solution of darker flesh tint the artist lays in the darker tones, studying the subject carefully through half-closed eyes to isolate the darkest areas (**far left**). *He uses pure black paint to demarcate the areas of darker tones on the bottom part of the subject's bikini. Paint what you see* (**left**).

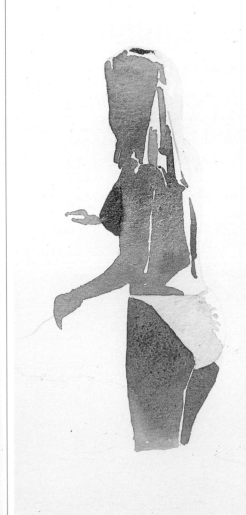

The artist continues to work into the bikini, using subtly varied tones to describe the form **(right)**. He lays in the darker skin tones, perceiving these areas as flat coloured forms, laying in the colours so that there are sharp lines to provide the transition between one tonal area and another. He does not bleed one colour into another, but these highly contrasted areas of light and shade convey very precisely the quality of sunlight on suntanned skin.

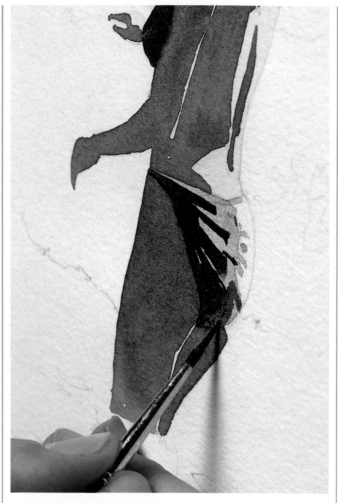

For the sky he mixes a thin wash of ultramarine blue **(above)**. He mixes up plenty of colour, to make sure that he has sufficient for the entire sky area. If you have to stop to mix more paint you will get hard-edged watermarks.

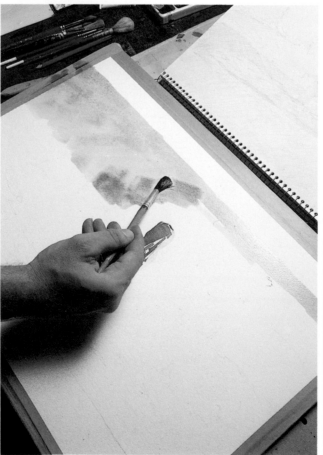

He lays in the sky, keeping the paint moving and not allowing the edges of colour to dry before the entire area has been covered **(left)**. He works quickly, scumbling (applying the paint so that the paper shows through in places) the paint to create the impression of high clouds. He uses large, sweeping gestures so that the sky area is rapidly filled. It is important to allow one layer of paint to dry before progressing to the next stage, this prevents one wash of paint from contaminating the next.

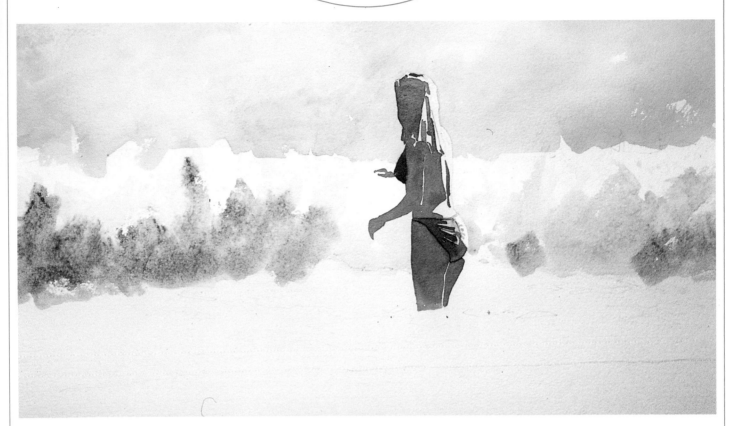

The artist has established the sky using a single scumbled wash **(top)**. Now he starts to lay in the sea by loosely working a solution of ultramarine, the colour which was used in the sky. A textured area of scrubbed and scumbled paint suggests waves and water **(right and above)**. The painting is allowed to dry at this stage.

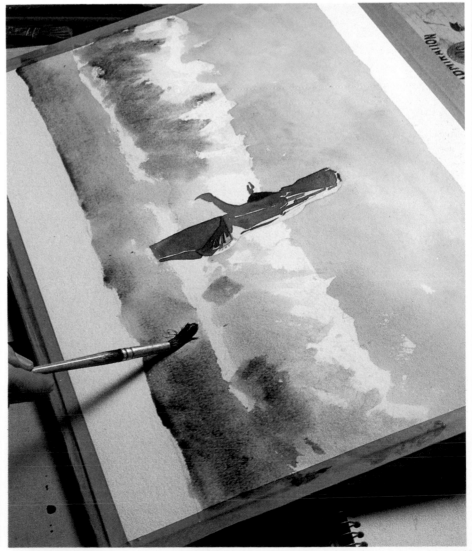

When the paint is completely dry the artist returns to the water areas. Using a dark blue he indicates the ripples on the surface of the distant water, using a brush of a size appropriate to the distance to be implied **(right)**. Marks farther away from the viewer should be smaller to create an illusion of distance.

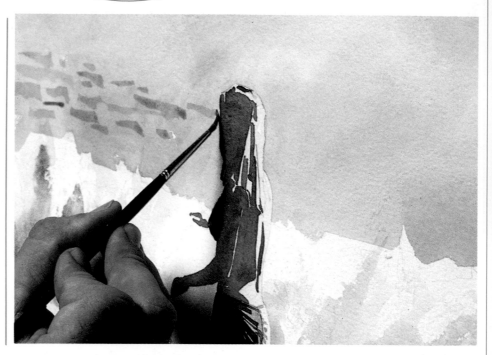

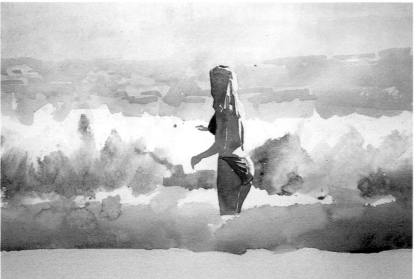

In the foreground he uses the same colour to work into the breakers so that in this area there is now a sense of movement, of swirling, splashing, crashing water. Gradually, as you can see, the image is beginning to emerge. The artist uses a variety of brushmarks at this stage, using the side of the brush to flick on vaguely rectangular shapes, and moves and twists the brush to create more amorphous shapes **(left and below)**. Using a suitable yellow, he lays in the area of sand in the foreground working quickly with large sable brush, well-loaded with colour **(bottom left)**.

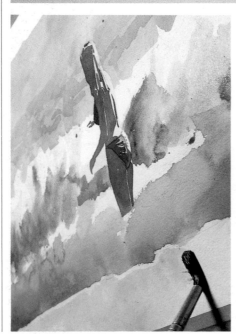

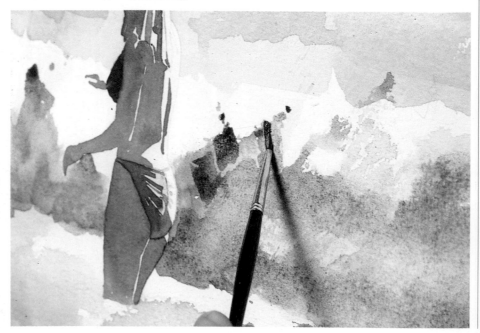

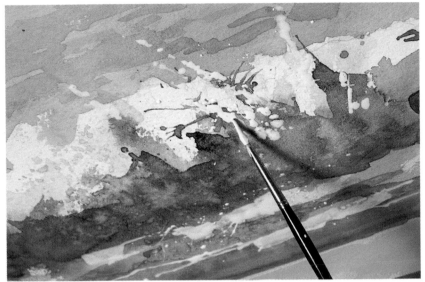

The artist now concentrates his attention on the area at the foreground of the painting where waves are breaking, creating spray and foam. He has already built up several layers of washes to create the water; now he lays on another layer of paint in which he has mixed a quantity of gum water and while the paint is still wet blows it to create the splashed effects you can see on the **right**. You can also see the way the paint surface gleams: this is caused by the gum water. He allows the paint to dry and then takes a decorating brush, dips it in clean water and splatters the area along the foreshore. This dries to create the watermarks which can be seen in the final picture. The foam and spray is completed by using a large brush to splatter on white paint. The final picture is lively and is an accurate reflection of the subject. The artist has used carefully controlled areas of colour to describe the figure. The water has been created with carefully organized layers of washes, adjusted to create the texture of crashing, foaming water. The painting is an excellent demonstration of the versatility and range of watercolour.

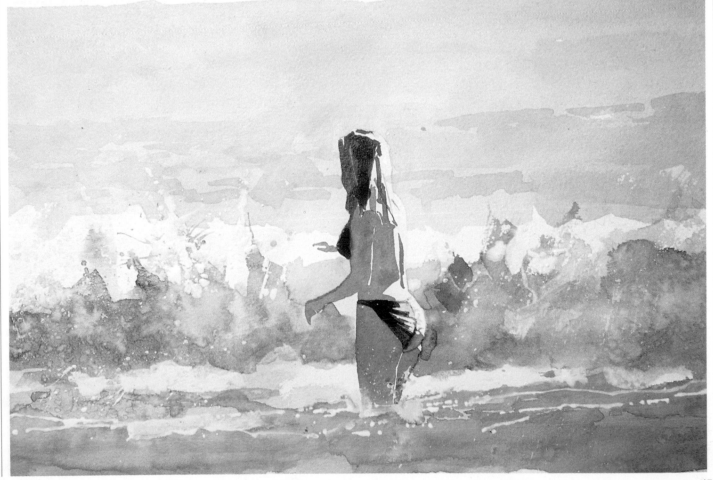

SEATED FIGURE: MONOPRINT AND PASTEL

Printmaking usually involves making an edition of near-identical images from one plate or block. The exception is the monoprint which is a print in that the picture is made on another surface and transferred to the support, but it is a once-only image. It involves removing ink from an inked plate by drawing with a stick, pen or a brush. The paper, which is going to accept the image is then laid over the inked surface.

Monoprints are sometimes used as a basis over which elaborations of colour or incised drawing can be added. Monoprinting is the most immediate means of drawing, enabling the artist to work with the kind of freedom normally associated with oil painting. The flexibility of the technique allows alterations to be made while drawing is in progress and it is particularly suited to representing strong tonal contrasts.

Try to introduce as much tone into your subject as possible, either by using strong lighting, or by using areas of light and dark tone in the surroundings (left). The monoprint technique is particularly suited to such arrangements.

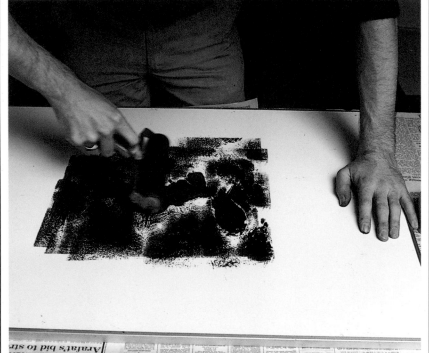

You will need a smooth, hard surface, such as formica; some black lithography ink; linseed oil; a roller; a piece of rag; a broad brush; a sheet of cartridge paper; some pastels. Add enough linseed oil to the black ink to give it a creamy consistency, and apply this to the sheet of formica with a roller (above).

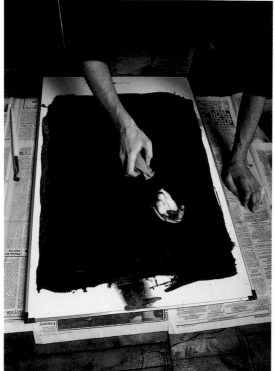

Use a broad brush or rag to start drawing the image in the ink. By removing areas of black, you will create highlights and light tones (above).

18

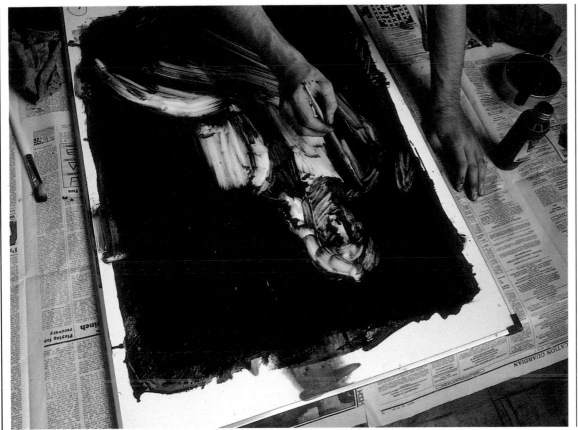

Use different brushes to make marks and textures in the composition (**left**). If you make a mistake, correct this by covering the area with more ink and starting again. It is also possible to draw back into the light areas with the ink to get detail or subtle shadow.

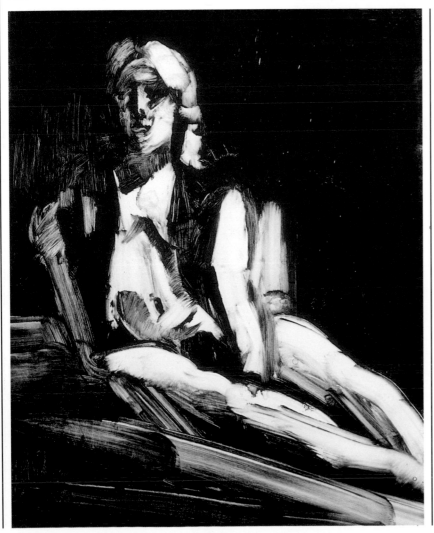

Leave the background tone as flat black and add any final touches before the printing begins. Do not worry if the highlights look stark and overstated at this stage — you will be working into this with the pastels later (**left**).

Place the formica flat on the floor and lay the sheet of cartridge paper over the image. Apply pressure over the paper with the back of a spoon (**above**).

19

The harder the pressure on the spoon, the denser your final image will be **(right)**. Try to burnish over the paper with a regular criss-cross movement. The burnishing movement will be reproduced in the print, the criss-cross pattern being seen on the black areas **(below left)**. Other textures can be obtained by moving the spoon in different directions.

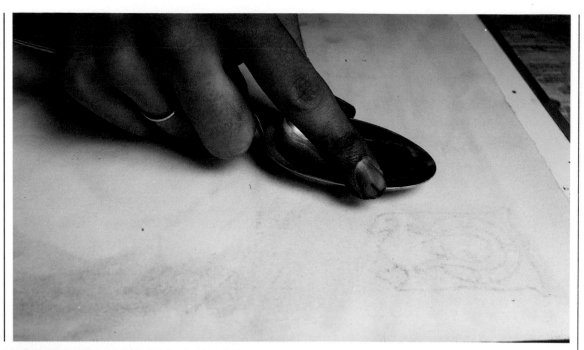

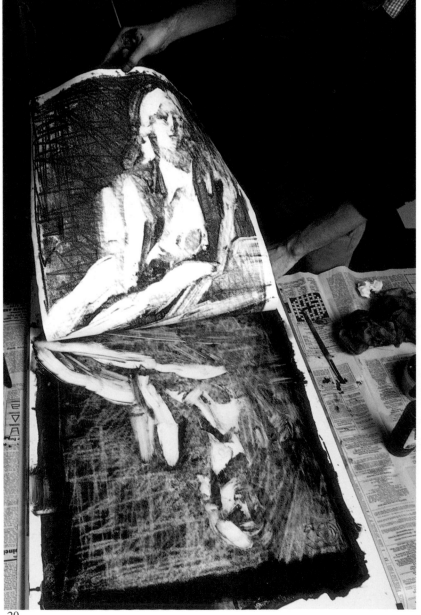

The resulting monoprint **(below)** is a mirror image of the subject. The basic printing method provides a patchy image with subtle streaks of texture, which is ready for further development.

Use a bright green pastel to enliven the background area, and work into the flesh shadows with light brown **(opposite)**.

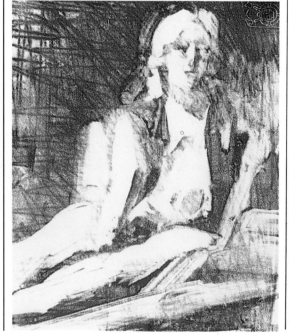

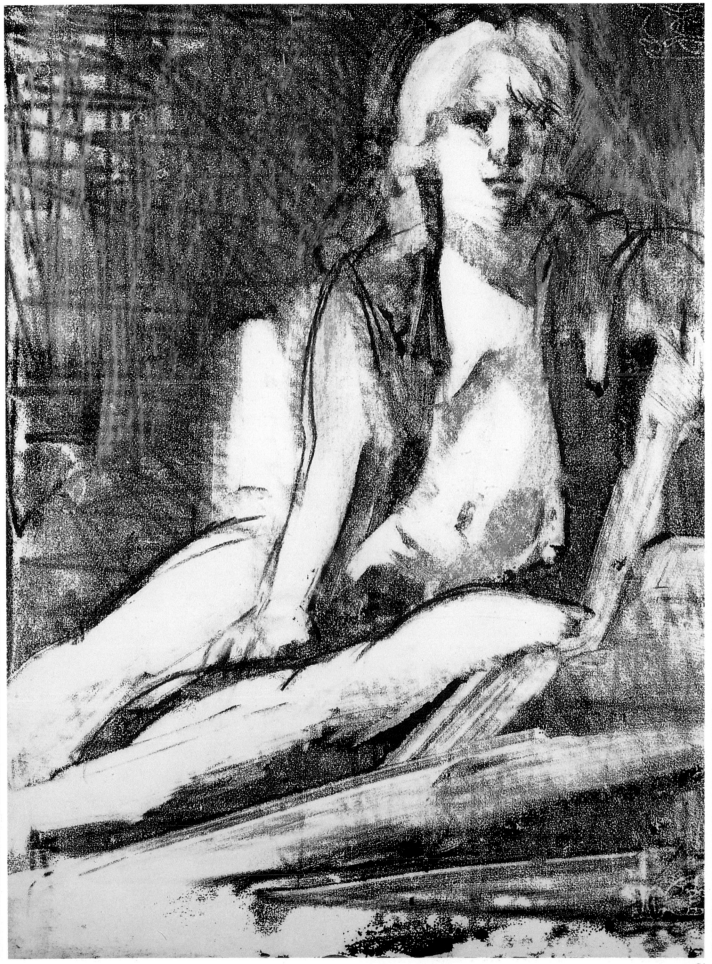

*Work further shades into the background in blocks of browns and yellows (**right**). The black ink lines will show through producing an interesting grainy texture. Use black pastel to darken the slightly dull finish of the lithographic ink.*

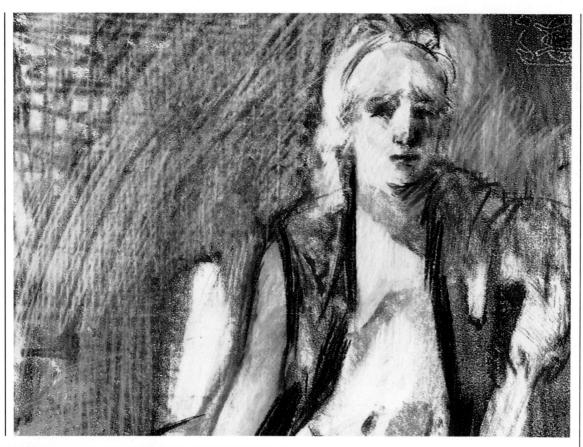

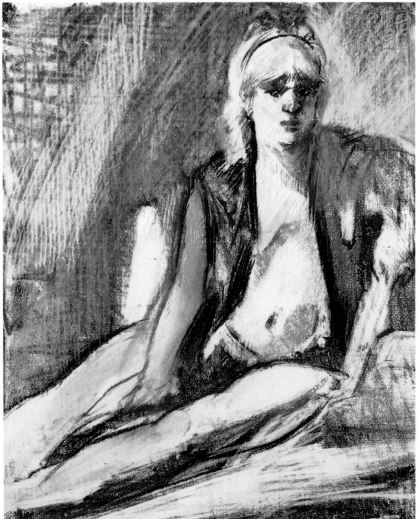

*Use a strong rust-red pastel to block in areas of shadow and some richer flesh tones. Add detail to the face, and bring out the volumes in the figure by using strong white pastel highlights to strengthen the existing light areas (**left**).*

*The finished picture (**opposite**) shows slight changes in the position of the figure, including a small change in the position of her arm, since the monoprint stage, illustrating the strength and versatility of pastel colour.*

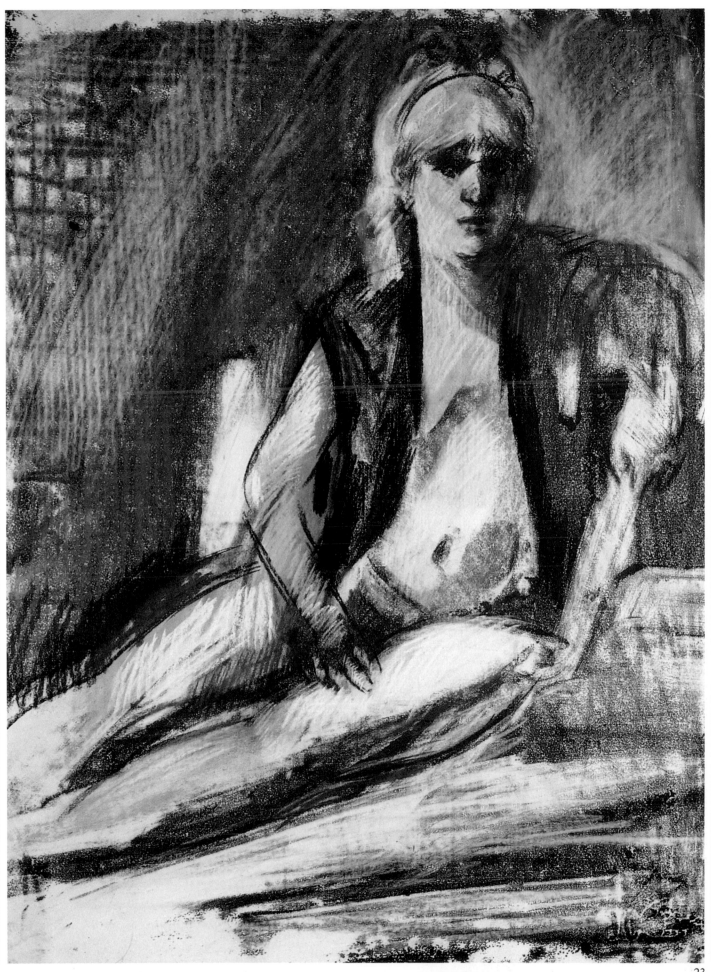

DEVELOPING A FIGURE COMPOSITION

Complex compositions can be developed from all sorts of reference materials, from sketchbooks, photographs, newspaper pictures and, as here, artist's models. The artist set up the figures on a table top and moved them around until he had found a satisfactory arrangement. He then developed the picture working quickly with dilute gouache. He wanted to capture a sense of movement and worked rapidly as he was anxious to counteract the rather static feel of the wooden models. He has created a nude group but it could be a clothed figure composition.

In this composition the high viewpoint adds to the interest of the group and creates a sense of motion. The heads of figures make one pattern on the picture plane, the feet repeat that pattern. The composition moves from the heel of the foreground figure, round and through the other figures and so into the background creating a sense of depth and space. Try a similar exercise yourself. Think carefully about the composition and use a frame to decide exactly what is going to be included in the painting. If you do not have access to artist's models you can use other objects to stand in for them. Alternatively, you could take this composition and base a picture of your own devising on it.

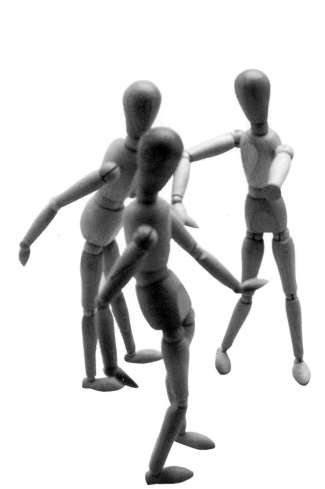

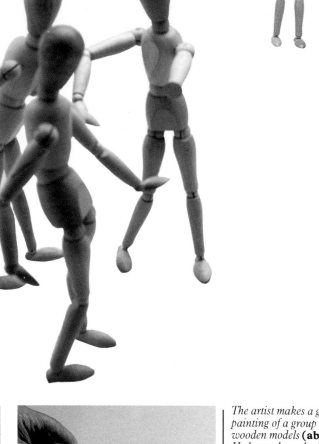

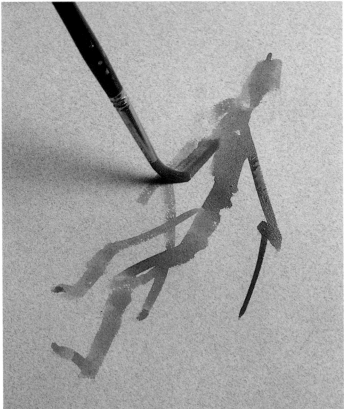

*The artist makes a gouache painting of a group of wooden models (**above**). He keeps the style simple, referring to the group of models for correct proportion and as a compositional guide. Drawing with a brush on tinted paper he allows the brushstrokes to represent the different sections of the torsos and limbs (**far left, left** and **below**).*

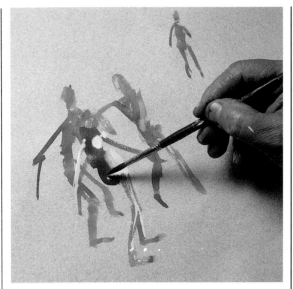

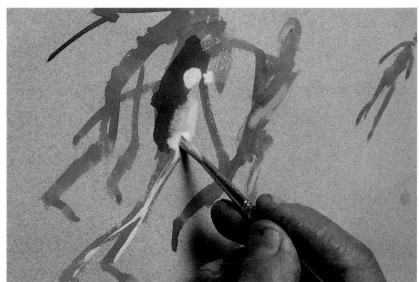

Using white paint mixed with Naples yellow for the highlights and a darker flesh colour for the shadows, he starts to develop the figures by describing the forms **(above)**.

He continues to paint directly onto the paper without first drawing an outline. Instead, he applies the paint to represent solid areas of tone **(top right)**.

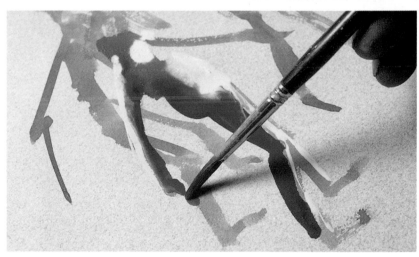

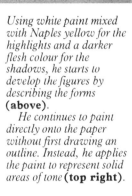

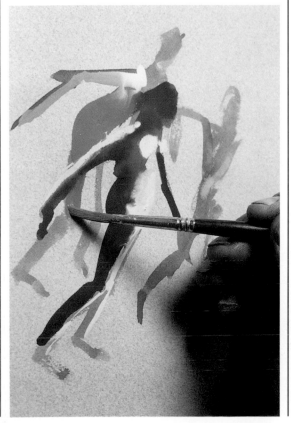

He varies the tone of the flesh colour on each figure; the lighting on the wooden models suggests the correct tone for each one. Thus he uses a strong tone on the foreground figure **(above)**, gradually lightening this to represent the lighter tones of the other figures **(left** and **below)**.

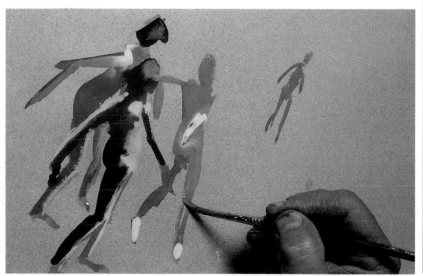

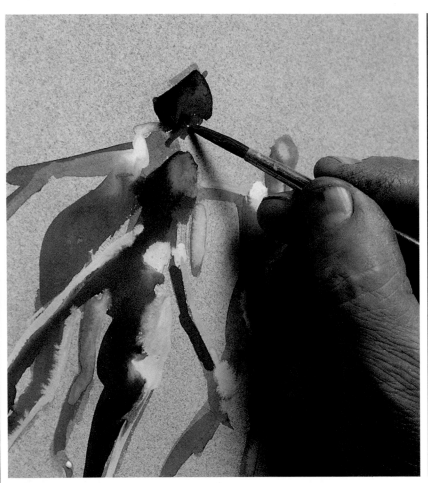

Without going into detail, he completes each figure by adding hair and face, allowing the brushstrokes to follow the form **(left)**.

He paints in the remaining figure, keeping the tone light in relation to the main group **(below)**.

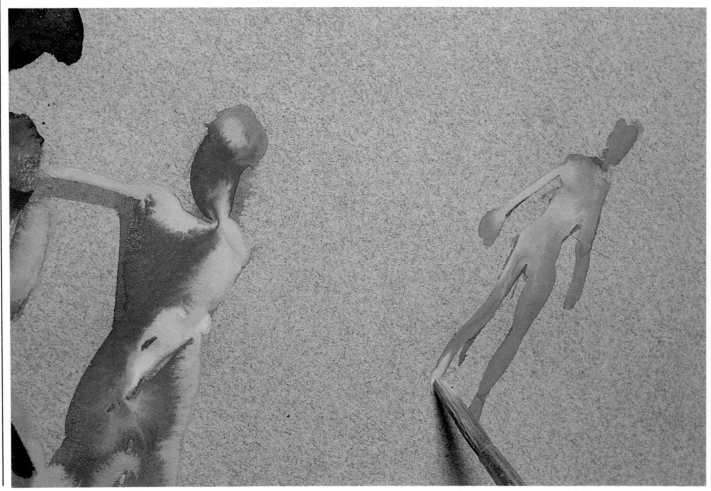

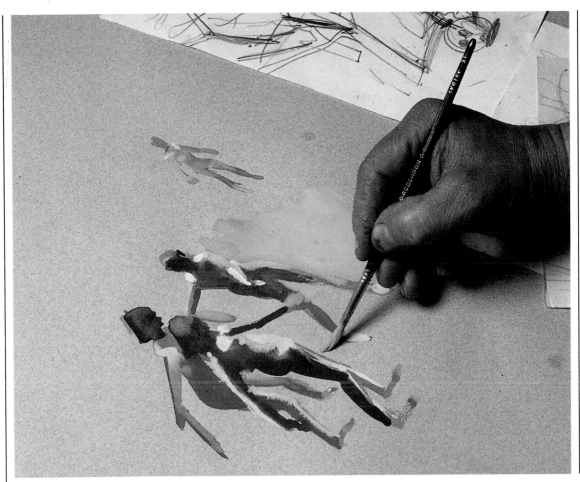

He mixes a light green for the grass, and using a sable brush takes the colour up to the contours of the figures, re-defining and clarifying the outlines of the group by painting the negative forms **(left)**.

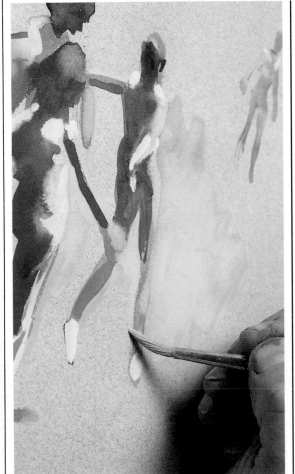

Introducing yellow and white into the grassy areas suggests dappled sunlight **(left)**. *Because he is working from his imagination rather than from a subject, the artist can allow the painting to evolve gradually, each stage suggesting the next.*

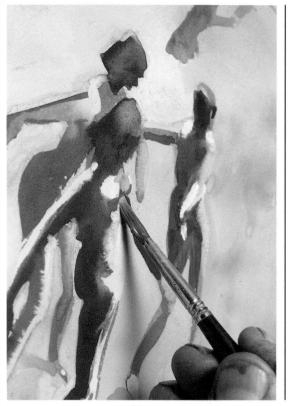

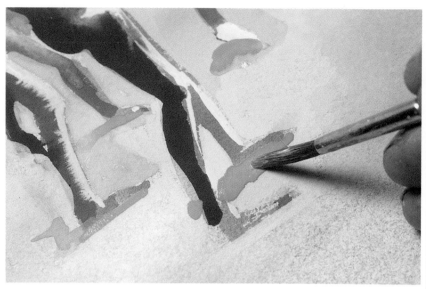

Darker tones are added to suggest shadow on the grass, fixing the figures firmly on the ground **(above)**.

The painting is beginning to take shape and the artist continues to work into the figures without referring to the original wooden models. He accentuates the rounded contours, increasing their human appearance without changing the basic proportions **(left)**.

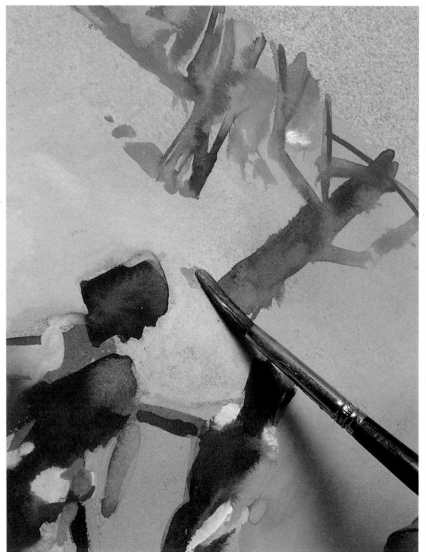

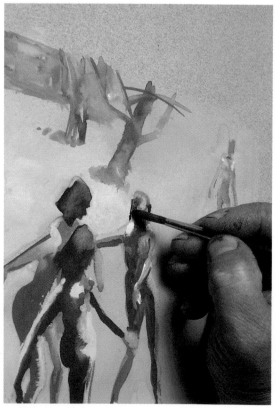

Add shadows to the trees **(left)**, in keeping with the general light source. Work across the whole image, bringing up tones and adding colour where necessary to help the composition work spatially on the flat paper **(above)**.

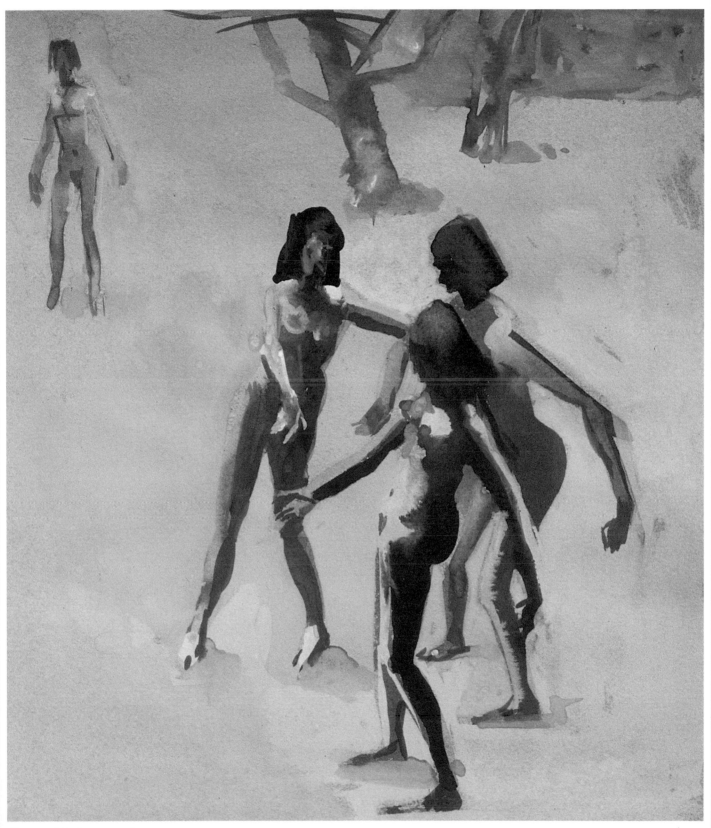

Because of the free approach and the absence of a preliminary drawing, the finished painting (above) shows none of the stiffness of the original wooden figures.

RECLINING FIGURE IN PASTEL

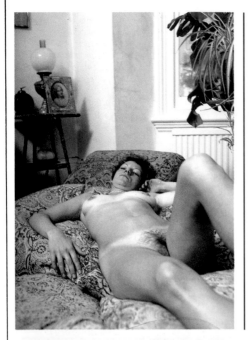

In this very free pastel drawing the artist has created a confined composition in which the figure is taken right up to the edges of the picture. This cropping creates an exciting composition, and a vigorous picture surface in which strong rhythms move across the support. The fact that the right leg breaks the picture frame brings the image up to the picture plane and enhances the three-dimensionality of the image.

The artist has used pastel with great freedom — it is a painterly rather than a graphic application of the pigment. See for example how the artist has established the equivalent of an underpainting, using grey pastel to pick out the main tonal areas. Over this basic underpainting the other colours are worked, adding layer upon layer and fixing as he goes. The image is free, exciting and impressionistic.

Pastel is an exciting medium. The pigments are in an almost pure form so it is possible to achieve rich, deeply saturated colours. The sticks are easily transported so they are useful for rapid sketching away from home. Colours can be laid on flat, or can be blended using a torchon or a finger. Here the artist has laid colours one over another, using a hatching technique which allows the underlying colours show through, modifying subsequent layers so that new colours are created by optical mixing.

Using grey pastel the artist lays in the volumes and direction of the planes on the torso and limbs (**left**). *He introduces the background colour, and works into the drawn outlines using blue* (**below**).

Working into the figure with warm and cool flesh tones, the artist overlays the pastels to produce areas of tone and colour **(left)**. He continues working into the figure, allowing the direction of the pastel to indicate the planes of light and shade. He builds up the colours with a firm, regular cross-hatching movement **(below)**.

He continues to develop the strong, directional colour of the figure keeping the hatching well spaced to prevent the pastel colours becoming dense and clogged.

The foreshortened body makes it necessary to develop the legs and the torso which dominate the picture. Work into the head and the upper part of the torso, bringing this into line with the rest of the drawing. The final picture **(over)** demonstrates the way a difficult and unusual composition can be used to create a dramatic image. It also shows pastel being used in a free but meticulous technique.

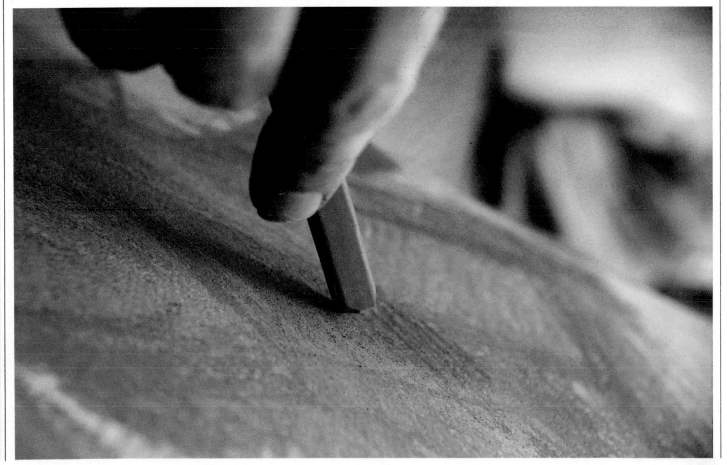

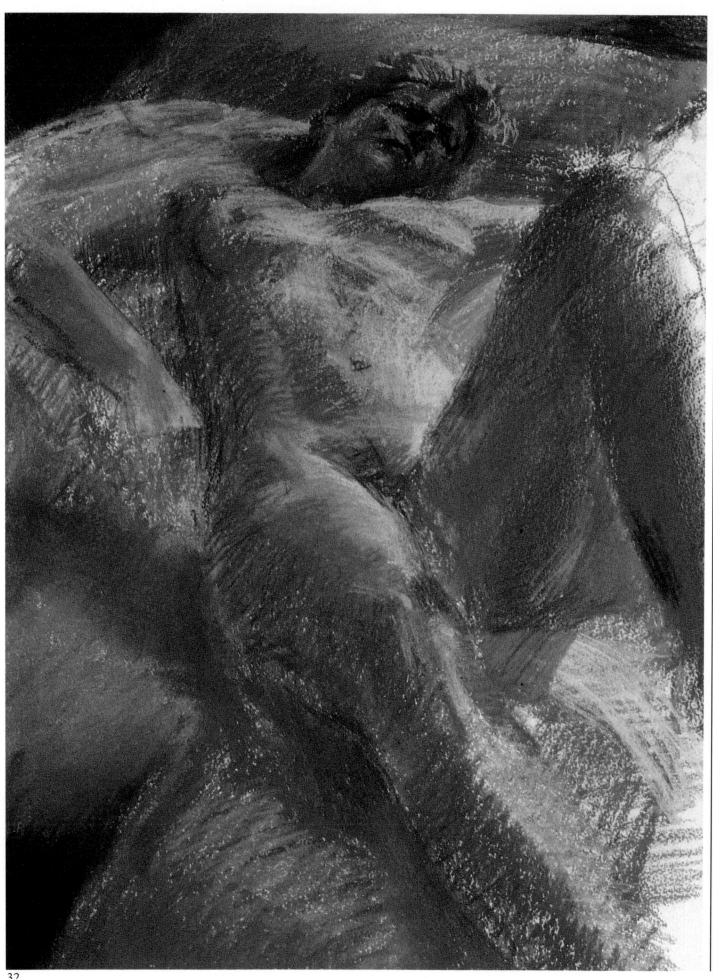